WORKBOOK

For

Girl wash your face

Stop Believing the Lies about Who You Are

so You Can Become Who You Were Meant to Be

Rachel Hollis

By

TIMELINE Publishers

Table of Contents

How to Use this Workbook For Enhance Application

Complete beginners can begin using this *Workbook* for Girl, Wash Your Face: Stop Believing the Lies About Who You Are so You Can Become Who You Were Meant To Be by Rachel Hollis to get immediate help of the major lessons and Summary of this book.

The goal of this Workbook is to help even the newest readers to begin applying major lessons from Girl, Wash Your Face: Stop Believing the Lies About Who You Are so You Can Become Who You Were Meant To Be by Rachel Hollis. Results have shown us that learning is retained better through repeated real-life applications

By using this Workbook, readers will find Summary and Lessons which we believed were major in defining the crucial messages of the author in the book.

There are Spaces to jot down your answers to lesson at the end of each Section. Take out a pencil, pen, or whatever digital technology you would put to use to jot down, implement, and make happen.

And don't forget to have fun – While at it. This Workbook Will aid in your path to growth, confidence, and believing in yourself.

The Background Story of Girl, Stop Apologizing

Rachel Hollis is an admirable personality that started her career as an event planner now turned entrepreneur. She is notable for her lifestyle blog named *TheChicite.com* amongst other outstanding feats; top podcast host, CCO of The Hollis Company, a TV personality, bestselling author on different platforms as she attained New York Times best-selling author of *Girl, Wash Your Face,* showcased by Inc. Magazine as one of the *"Top 30 Entrepreneurs under 30"* in 2009, married for 11 years now and blessed with a supportive husband David Hollis and mother to 3 sons and a daughter.

Studied American Academy of Dramatic Arts in Los Angeles; born on 9th January 1983 in California, United States. Rachel Hollis has other fictional book series to her name called *The Girls* and cookbook recipes exploring her culinary interest. Her motivational speaking has touched the lives of many women all over the world.

Introduction

Girl wash your face, by Rachael Hollis has come to inspire many females as she not only encourages them but goes further to exemplify by narrating her life challenges and how she responded to every single issue and how it has shaped who she is today.

This is not your regular workbook; this is like a daily manual to keep your goals and aspirations closer to you than ever. This workbook contain lessons, goal, action points and check list. The aim of this workbook is to better enhance your reading experience and assist you in making more actionable goals, habits to desist from, new ones to adopt, skills to enhance a better you, lifestyle changes and everything you need in general to be your best-self.

Chapter One: The lie: something else will make me happy

Learn to accept your flaws

Not having a flaw is a flaw in itself. How many lies are you fond of telling yourself? Has the lie been able to make you happy? And how long will you continue to do this to yourself?

At times I feel we forget that we are only humans and imperfection is part of our DNA. It's ideal to strive to be better but not at the detriment of your sanity. Your imperfections are what makes you human, those flaws give you the reason to aim to be better at what you do every day. Even after surmounting one hurdle; another one arises, and so on. The necessity to survive at all cost should guide your focus to be great because at the end of the day it's your life and should be lived up to the fullest. Life isn't here to be endured but enjoyed, focus more on your aspirations and goals, not on limitations. Identifying what you lack in other to work at it is proactive; don't magnify them as it will not suppress their effects in your life.

The only way to successfully defeat the strong urge trying to weigh you down because of your weaknesses is to acknowledge that it exists, embrace it and make intentional steps to bring out the best from that awkward imperfect situation.

> ## Lesson

1. Only you can determine how your life turns out, no situation or challenge can decide that.

2. Every step you take to discover your best-self matters a lot.

3. Our imperfections are what make us human and we are to work at it.

4. Only fighters make headway in life and get the best out of it.

5. A positive approach to the very worst of situations can magically make the best of it.

> **Possible reasons why these imperfection lingers**

1. What are those flaws that keep you back from pursuing your dreams?

2. What makes you vulnerable and exposes your weakness more?

3. Have you ever tried working on your limitations and what is the progress so far?

2. Did your childhood fuel this imperfection or what exactly happened that made you aware that you are lacking some key traits that is hindering your progress in life?

➢ **Goals**

1. What goals will you set today to help you better accept your imperfections and attempt to use it to your advantage?

2. How far would you have gone in improving on those flaws by the end of 6months ?

3. What long-term goal do you hope to achieve from doing this?

> **Action steps to get you where you ought to be**

1. Approach the flaw head-on, with the right motive and an unwavering focus.

2. Habits to adopt today to help you embrace your flaws.
3. Do away with haunted memories that have kept you back from being your best-self all this time.
4. Channel your misery positively and with the right attitude and it will turn the situation around for good.

> **Checklist to note as you embark on this journey**

1. Work on your confidence level. Like I always say, confidence is a skill, groom it and it will grow as it plays a vital role in facing challenges of life

2. Be resolute never to give-up as you go through the journey and you will win.

3. Avoid events or people that bring out the worst in you and hinder your progress.

4. Hit the track with a positive and dogged mindset, you are not different from other people; you only want more and you are not comfortable to settle for the status quo.

Chapter Two: The lie: I START TOMORROW.

My take on procrastinators; they don't respect their time and won't respect themselves either. It's a common practice amongst us humans to push for tomorrow what we can do now, and then with time, we forget to do it all together. We forget that time keeps marking as it goes and it waits for no one. When we realize the damage done most times its already too late; not only have you wasted time but also deviated the focus to those ones that looked up to you.

Decide to be the unique human who always tackles the challenges as it comes. It will make you focused as you achieve all you need to be done today and face that of tomorrow as well. Make yourself a promise to succeed at all cost and live by it.

It is important to start the self-disciplined culture with your personal daily activities before embarking on the life-changing goals that have long-term benefits. This way, when you are able to respect your time and make good use of it at every given opportunity; you will be able to do the same for the other people.

> **Lesson**

1. Delay is lethal; don't pile up for tomorrow what you can do today.
2. Be honest with yourself; time is not on your side and begins that chase to your goals today.
3. In other to be outstanding, you need to always make and embark on your goals as it comes.
4. Living a life of procrastination affects every part of your life, with time one will begin to keep postponing everything for later.

5. Embark on training yourself to take life more seriously and others will take you seriously as well.
6. We can learn to build the habit of not procrastinating just as we groom our confidence level.

➤ **Possible reasons why you procrastinate**

1. What are your fears and why has it limited you?

2. What factors can you attribute to your procrastination?

3. Which of the goals in particular are you fond of procrastinating?

➢ <u>Goals</u>

1. What are the set of goals you are procrastinating and why?

2. Are your goals feasible and why do you think they are?

3. What are the measures you are going to take to henceforth help your procrastination?

Action steps to get you where you ought to be

1. Be intentional about how you use your time.
2. Do what needs to be done as the matter arises.
3. Asides making mental notes of your goals; make written notes in your personal journal so you don't lose sight of your vision.
4. Ask for help from others to ease the burden of achieving your goal if applicable; because sometimes the weight of our goal seems to be insurmountable that we pretend to forget it
5. Have friends that respect their time and don't procrastinate.
6. Start with one goal per time in other not to be overwhelmed.

➢ **Checklist to note as you embark on this journey**

1. Disassociate yourself from timewasters or any event that draws you far away from your goal.
2. Separate your cool ideas from your goals and place them in their manner of priority.

Chapter Three: The lie: I'm not good enough

In real life, not those picture perfect lives painted by some writers. It gets really hard and overwhelming;and makes you feel it's time to throw in the towel and say you can never be good enough to face the challenges. But that isn't true; there is always a way as long as you are determined. Find out what works for you and stick to it. Time management is the key, to be able to effectively and unarguably contribute your quota to your family and your goal, it all boils down to how you manage your time, this factor cannot be evaded.

➢ **Lesson**

1. Slow down when you have to, it doesn't mean you are not doing your very best. When you rest, you are at liberty to refuel the body and regain better focus to face the hurdle in front of you.
2. Find out what works for you and stick to it.
3. No matter the situation, find joy in what you are doing. It's little but very effective.

➢ **<u>Possible reasons why you feel you are not good enough</u>**

1. Why have you concluded that you are not good enough?

2. Would you say that your conclusion of not being good enough is attributed to societal pressure, peer pressure or family pressure and why?

3. Can we say that the fear of competition is one of the reasons why you feel you can never be good enough in your chosen industry?

Goals

1. What goals are you setting up today to correct that faulty mindset of not being good enough?

2. Do you think you should seek medical or other professional help as to why you feel you are not good enough?

3. What are the things you wish to rearrange in your priority list today?

➤ **Action steps to take**

1. Avoid letting peoples opinion about your life form you, you are just enough for your goals
2. Make conscious efforts to silence that tiny voice in your head that tells you "you are not good enough"
3. Don't wallow in self-pity; make active decisions today that will have positive effects in your life.
4. Don't attribute your ordeal to anyone, take full responsibility and correct what needs to be corrected.

➤ **Checklist to note as you embark on this journey**

1. Wade off depression and tell yourself you are more than enough.
2. Make sure you embark on this journey with one goal at a time.

Chapter Four: The lie: I'm better than you.

It is a useless venture to bring someone else down in other to rise. Or should I say it's futile to speak ill of someone as that will not surge you far ahead into your own goals? Give everyone a benefit of doubt; don't assume the worst of people every time. When conclusions are drawn from a place of fallacy it can stop your progress of discovering your best self. Draw your conclusions from facts. Haven't you heard of cheering your competition before? Cheer on, for life is too short. You don't have to assume the best of someone until you come closer to them to know who they really are, even from afar let positivity lead you on and before you know it, positive vibes will ripple out of everything that concerns you.

> **Lesson**

1. It is out of order to judge others.
2. Don't walk around hating on people because of the way your life has been. For the fact that life has been unfair to you doesn't mean you will be unfair to others.
3. No two realities are the same, don't live a judgmental life.

➤ **Possible reasons why you are feel you are better than others**

1. Do you have judgemental traits and why do you think so?

2. Could it be that inferiority complex is one of the reasons why you are always on the defensive and judgmental terrain? If yes explain why.

➢ **Goals**

1. What goals are you setting today to rid yourself of any judgmental traits?

2. How do you intend to successfully surround yourself with positive people?

3. What new life principles/habits do you need to adopt to make you less judgmental?

➢ **Action steps to get you where you ought to be**

1. Stay away from hearsay and baseless assumption. Base your life on facts, not a fallacy

➢ **Checklist to note as you embark on this journey**

1. Do away with judgmental friends today.

Chapter Five: The lie: loving him is enough for me.

Love yourself enough; this is your sole responsibility as a woman. We do too much to prove a point in our relationships. We hold on to the tiniest thread and take whatever is thrown at us because we want the health of the relationship to remain intact, in spite of everything going wrong. We tend to turn a blind eye to it and keep on loving foolishly.

Don't go the extra mile to prove your love especially when it isn't mutual. If it is meant to be, it will be seamless with no strings attached.

Don't be afraid of taking a walk when it's sapping your sanity, it doesn't have to be easy, but may be the only way to get yourself back on track.

> ## Lesson

1. Learn to love yourself; no one will love you as much as you would better love yourself.
2. The value you place on yourself determines how others treat you.
3. Love clouds your judgment, to make rational decisions that will positively affect you; you have to go an extra mile to be truthful to yourself.
4. Stop lying and giving excuses for the other party to mistreat you. Take responsibility for your life and do what needs to be done today not later.

➤ **Lists of things to look into**

1. Would you describe your relationship as a healthy or unhealthy one and why do you think so?

2. Do you think that suffering from several heartbreaks can determine the course of your future relationships and why?

3. What foundation is your relationship built on?

➢ **Goals**

1. What goals will you adopt today about your relationships (to improve or take a walk and why)?

2. How do you intend to handle a toxic relationship if
 you are in one?

➢ **Action point**

1. Get yourself some self-respect.
2. If your relationship is questionable re-think it today.

➢ **Checklist**

1. Check on the status and gains of your relation first.
2. Determine if the relationship is one-sided or mutual.

Chapter Six: The lie: No is the final answer

'

No!,' should never let you lose hope or hang the rope. Keep at your dream, keep knocking on those doors, keep ringing up those numbers, and keep sending out those emails and letters till a positive response comes in. Don't ever be comfortable with settling for less or the norm. When you get the opportunity you have been searching for; work so hard, that they don't have to ask you the secret of your success because it is visible for all to see.

As you go on, you may fail, you will get stressed out; you will be over-whelmed no doubt... Just ask for help when necessary and keep improving yourself and your dreams. All the doors cannot shut at you at the same time, there is always a way; search deeper and you will discover it.

Be more daring in tackling your goal; keep your eyes on the goal no matter what gets in your way. Keeping your eyes on the goal doesn't mean you will harass the desired response out of the person because that will land you nowhere; instead, try a different route.

Write your goals boldly where you can see it so as you run you will not lose sight of it.

Lesson

1. See rejection as only part of the game and not the final conclusion of the matter.
2. Don't stay down too long when you are declined; get up find new methods to get your goals achieved.

3. Never take no for an answer.
4. Always strive to live above the norm.
5. Never be ashamed to ask for help as you journey towards achieving your dreams.
6. Spell out your own limitations and get to work so that no one else is telling them to your face.

> **Possible reasons why no has been the answer for too long now?**

1. Do you think you are chasing the wrong dream and why?

2. How have you been approaching your goals all this while?

3. Is your dream taking too long to actualize and why do you think so?

4. What are the challenges you face as you pursue your
 goal?

5. What are the things you feel if you have available will
 make achieving your dream a lot easier?

➤ **Goals**

1. What have you Identified as the things that needs to stop and is hindering your progress?

2. Due to the recurrent negative responses you have gotten so far, how do you intend to approach the situation differently to get the response you desire?

➢ **Action steps to get you where you ought to be**

1. Review your goals and make sure it's one project at a time.
2. Reach out to others who have walked the terrain you aim to thread on and ask for advice.

➢ **Checklist to note as you embark on this journey**

1. Approach the challenge with the aim of succeeding
2. Meet people you know that have experience in the same field your passion thrives in.
3. You might fail this time but try again because you will definitely succeed.
4. You can start with the easiest task on your plate and get that accomplished; the feeling of accomplishment has a way of fueling your attempt on your next goal.

Chapter Seven: The lie: I'm bad at sex.

Sex has always been a controversial topic that has either cemented many relationships today or broken it into tiny little bits. Haven mentioned the necessity of mastering our craft times and times again, same goes for the subject of sex. Sex is a blessing that should be enjoyed not endured; when it is endured there is a problem. Just like Rachel and her ordeal when she newly got married. She had little or no experience about sex, so it took her so much to figure her way around it and it even got worse when she started having children. But as the brave woman that she is, she spoke out and help came.

Several factors can cause this change. Discard your faulty orientation about sex. Trash the image in your head that makes you see sex more of a hectic job than the fun that it really is. You are the only one holding yourself back from enjoying every bit of sex. You are permitted to be weird and candid about love-making as possible as can be, it's your husband you are with; so what's the hold for? Learn to accept your body; don't let it deny you the pleasure of a good time.

Don't be ashamed of your orgasm; always look out for it and it will happen.

➢ **Lesson**

1. First, be aware there is a problem and focus on finding solutions.
2. You can abstain from sex as long as you wish and still learn the act while in your marriage; it is possible; Rachel did it.

3. To move ahead of any challenge in life, you need to bring it to the light and trash it.
4. Understanding your body and what it loves is key to the way sex will turn out for both of you.
5. Having more sex will make you have good sex and appreciate love-making.

➢ **Possible reasons why you are bad at sex**

1. What negative experiences are tied to your sex life?

2. What is your orientation about sex?

3. Is your upbringing or background one of or the major reasons for the uncomfortable way you feel about sex?

4. Are there any medical conditions causing this and if any; what have you done to alleviate the problem?

5. Is your appearance the cause of the bad sex, if yes why do you think so?

➢ **Goals**

1. What do I need to do to help me enjoy sex more?

2. What measures will you take to boldly approach your spouse and talk about your fears, limitation and reservations on sex?

3. Write a positive self-talk about how great your body is and how sexy you are. When done; read it to yourself every day and soon you will start to believe it.

4. For that boring sex life, what measure do you have in place to reignite the spark?

➢ **Action steps to get you where you ought to be**

1. See sex as fun, not as a burden.
2. Always look forward to another beautiful episode of lovemaking and by every love making session, you will get better at it.
3. Explore each other as much as you like, this way you will even find out new spots to better arouse your spouse.
4. Add more spice to your sex life so it doesn't get boring or routine-like.

➢ **Check list to note as you embark on this journey**

1. Have the right mindset for sex.
2. Sex is to be enjoyed not endured.

Chapter Eight: The lie: I don't know how to be a mom.

It's okay to be scared; this is your first time being a mom and can be jittery. Even our sturdy Rachel wasn't any different as she explains her own ordeal in preparing for her first child birth. It is okay to worry but more thoughtful to be proactive and worry less.

Focus on taking good care of yourself and the baby. Eat meals and liquids as advised by your medical practitioner. Seek help in ways to take care of the new born; you don't have prior experience; so be open to assistance. Don't wallow in isolation, join a group that houses many new mothers and learn from them. Get out of the house every day and take a stroll with your baby, leave the scene you are used to, it will help you feel better.

Speak to a trusted person and share you challenges, it will aid you find succor and techniques to overcoming the way you feel.

> ➢ **Lesson**

1. It is very hectic for a first time mum, especially one without help.
2. The justifications and fear are understandable.
3. Seeking help aids the situation.

➢ **Possible reasons why you feel you don't know how to be a mom**

1. Have you ever been a mom and failed at it and why?

➢ **Goals**

1. What healthy lifestyle goals would be great for your health and that of your baby?

2. What Items will you like to research further on as regards your health and that of your baby?

➢ **Action steps to get you where you ought to be**

1. Read wide and research everything you need to know about your present status.
2. Join a club/group today where new moms gather to share experiences and tips on how they succeeded I weaning their child.
3. Intentionally stay off from things that raise your anxiety, emotions negatively and insecurity within this period. Be it social media or event, stay off for now and get all the rest you need.

➢ **Check list to note as you embark on this journey**

1. Embrace your fears for it is only for a season.
2. Join beneficial groups that will impact and support the cause for which you joined the team.

Chapter Nine: The lie: I'm not a good mom

Being a new mother and being a mother is a totally different ball game. Being a new mom can be learnt from a written manual for many new moms to follow; but being a mother is to learn on the job as you can be faced with anything at any time of the day.

Nevertheless, as you go through it, you become more experienced at the responses, advices and teachings you give your child. Being a mother cannot be learnt all in a day, a lot unfolds as the day goes by.

For the fact that other mother's handle their homes in a certain way don't mean you should copy same, it may not work. You handle issues differently and there is nothing wrong with it. Find out what works for your family and stick to it.

> ➢ **Lesson**

1. The fact that you can give birth to a child does not make you a great mother.
2. Making out time to be with your children is enough impact.
3. Stop spending time sieving all the things you are doing wrong as a mother; instead look at the bright side.

➢ **Possible reasons why you feel you won't do great as a mom**

1. Why do you think you are not a good mom?

Goals

1. What manual do you think you can adopt to make you productive to your children and your general household ?

2. What measures will you take to strengthen the bond between yourself and your kids?

➤ **Action steps to get you where you ought to be**

1. Find out what works for your family and stick to it.
2. Make friends with other mums your children are comparing you to and see what you will learn from them.
3. Spend quality time with your kids and focus your energy on them from time to time.

➤ **Check list to note as you embark on this journey**

1. Focus on what you are doing best not what you are doing wrong.
2. List out ways to be better at being a mother and pursue it.

Chapter Ten: The lie: I should be further along by now.

Comparison in itself is not a bad word only if you make it look like one. It's bad that people talk down on others because they are yet to attain the status they ought to be; worse still is when this derogatory statement is coming from self-thoughts. There is nothing as damaging as that tiny voice inside your head telling you that you cannot go far in life. Jealousy does not change the status quo of the person you envy, there is time for everything and everyone under the sun, go through your process and finish strong.

Continue chasing your dreams, set the goal and keep working at it; your agitation will not make it come sooner. It will materialize when the time is right. But never give up on your dreams until you have what you desire.

➢ **Lesson**

1. Learn to succeed in your present circumstance.
2. Don't look out to compete with others, there is time for everyone; trust in the process.
3. Don't be too embarrassed to express how you really feel.
4. Keeping quite empowers those lies you are telling yourself.
5. Learn to set goals not deadlines.

➤ lists to consider

1. State your reasons why you feel you should be more than what you are now.

2. Are the deadlines you set a reason to make you discouraged and limited? Explain why?

Goal

1. Make a list of the things you have accomplished till date.

2. Change all your time limits to goals and write them down here.

➤ **Action steps to get you where you ought to be**

1. Make your goals actionable and do-able.
2. Don't work with envy any longer, focus on you own dream and get the job done.

➤ **Check list to note as you embark on this journey**

1. Don't be too hard on yourself and praise yourself for every accomplishment you have attained.

Chapter Eleven: The lie: other people's kids are so much cleaner/better organized/more polite.

Still on the subject of common lies we tell ourselves as it relates to comparison and the effect of being drowned in it can do to us. It is one thing to be faced with a situation; and another thing to choose the reaction you want to give as your feedback. Of a truth, you cannot control the situations you are faced with, but you can control your reaction.

When we are faced with daily challenges, people either pretend not to see it and admit not to know about its presence, others fight it and are left bitter/angry because we failed to plan adequately and therefore failed in carrying out our duties; while others wallow in it as they are overwhelmed by everything going on around them. We forget to swim our way back up to the top and take everything one at a time; you possibly cannot do everything at the same time; that's why you have been failing all this while.

> ➤ **Lesson**

1. Find out what would work for you and stay with it.
2. You cannot be in control at all times, seek out new methods to approach the situation.
3. Seek the help of God to help you
4. Search for help in the right places, take the advice from authorities and run with it.

➢ **Possible reasons why you are faced with this challenge**

1. What key areas in your life needs urgent attention and how do you intend to accord them today?

➢ **Goals**

1. Write down your priorities based on what you term important.

2. What is that comfort zone you love to goto, to unwind in other to get you to that happy place.

➤ **Action steps to get you where you ought to be**

1. Get friends that can relate to your world, it helps to relief stress.
2. Understand what you want and go for it.

➤ **Check list to note as you embark on this journey**

1. Solutions are to be based on what you are going through not what you see happening around you.

Chapter Twelve: The lie: I need to make myself smaller.

We strive so hard to please people and gain their approval about our lives. We do anything within our power to be in their good book. This is what we term being successful.

Many times our achievements are downplayed and projected as a normal feat for one reason or the other. Nevertheless, don't bring yourself low to the world's opinion about you. Instead be confident of your achievements and tell it to who cares to listen because you might just be helping someone who has been in dying need of a voice.

➢ **Lesson**

1. How far you go in life is totally dependent on you.
2. No one can set the limits for how high you can go but you.
3. Don't downplay your achievements or accept the defeat of someone doing likewise to you.
4. Bother less about what others will think or say about you.

> ## Possible reasons why you feel you need to bring yourself lower

1. Why are you downplaying your abilities and accomplishments?

➢ **Goals**

1. How are you going to change being a peoples-pleaser?

2. What bold statement are you making today concerning your life?

3. What do you need to improve on?

➢ **Action steps to get you where you ought to be**

1. Aim to offend by being unapologetic about not needing their approval to succeed.
2. Set an appointment with an authority in your field and get tutored the more.
3. On your own read wide on content beneficial to your goals and get results.

➢ **Check list to note as you embark on this journey**

1. Don't speak low of yourself.

Chapter Thirteen: The lie: I'm going to marry Matt Damon

Learn to set realistic goals and run with them. It's ridiculous to make such vague propositions with no plan in sight just as the heading of this chapter says. But many of us make such plans and start running around in circles not getting anything meaningful achieved but wasting time in the process.

After setting dreams that can be worked on, focus all you have got to make it come to reality.

> ## Lesson

1. Learn to set feasible goals
2. Make sure to work at seeing those goals achieved.
3. In other to get closer to you dream; make friends with your idols.

> ## Goal

1. Dare to dream of the impossible you want that will turn your life around? Let's hear it.

2. Write down your feasible goals.

3. Create your own vision board that constantly reminds you of where you want to go.

➤ Action steps to get you where you ought to be

1. Surround yourself with inspiring people that will support your dream.
2. Keep saying what you want achieved exactly and aloud

➤ Check list to note as you embark on this journey

1. Do a routine check on your goals to ascertain that they are all feasible and practicable.

Chapter Fourteen: The lie: I'm a terrible writer

There is no profession without its hazards, even writing. People will always give you feedbacks, some you will like and other you will detest. Same goes for writers, while some reviews will make you fly with wings; some others will cripple your passion to write. But guess what; other people's opinion about you doesn't count.

If you are laid back to getting those long awaited publications in copy for a multitude to read because of fear of what readers and critic might say or fear of rejection from publication houses; then you have not resolved to making it. Just get it published.

➢ **Lesson**

1. You have no business with someone else's opinion about you.
2. Only you know the level of your abilities.
3. Not allowing the crowd silence your gift only shows how strong willed and resolute you have become.

> **Possible reasons why you feel you are a terrible writer**

1. What is the origin of your self-doubt?

➢ **Goals**

1. What are the measures you need to take to stop letting the bad reviews get the better part of you?

2. What and what will you start today to gain positive reviews in your given field?

➤ **Action steps to get you where you ought to be**

1. Be open about criticism, that's a way to learn.
2. Set out to get your goals achieved and disregard what others are saying.

➤ **Check list to note as you embark on this journey**

1. Treat the reactions of others as second fiddle.
2. What is your reason for embarking on this passion?

Chapter Fifteen: The lie: I will never get past this.

There is no situation that one cannot get past when you put your mind to it. Emotions may soar, we are only humans and we make mistakes; just mourn accordingly and move on. Have it in mind that some sad scenarios can shape your life positively or negatively, which ever one it is, depends on your reaction to the situation.

> ## Lesson

1. Everything you are going through shall pass in time.
2. The scars will forever remain but working on the thoughts can give you another reason to live.

> ## Possible reasons why you feel you will never get past your troubles

1. Why are you holding firmly to your past?

➤ **Goals**

1. Measures you have to take to forget that painful part of your life that holds you back.

2. Talk about the terrible situation you experienced and why you are ready to let go of the pain now.

3. What do you need to do to get full control of your thoughts?

➤ **Action steps to get you where you ought to be**

1. Make conscious efforts to move forward regardless of the hurt you feel.
2. Go for therapy with a trusted practitioner.
3. Talk about what you are feeling, by so doing you will lighten your burden.

➤ **Check list to note as you embark on this journey**

1. Be in total control of your thoughts.

Chapter Sixteen: The lie: I can't tell the truth.

The need for honesty in every facet of our lives cannot be overemphasized.

> ## Lesson

1. Being resolute can help you achieve your goals
2. Honesty is a real virtue.
3. Be honest with yourself about the things you want and be tenacious about it.

> ## Possible reasons why you feel you can't tell the truth

1. What experience has left you feeling that you cannot tell the truth?

> **Goals**

1. What measures will you adopt today to become honest?

> **Action steps to get you where you ought to be**

1. Find the courage to be honest to yourself and what you are going through.
2. Surround yourself with people who strive to be honest about their feelings, these ones have confessed to their suffering and how they have lived with it.

Chapter Seventeen: The lie: I am defined by my weight.

When emotional outburst occurs, its common practice is to find solace in the arms of food, although this is relative as many people react differently. This is not bad news; the horrible news is when these ladies choose to crave highly cholesterol and fatty food. They will not help in alleviating the sorrow they feel and this binging is only temporary.

After some time, she must have added so much weight and will be forced to embark on to the slimming – down battle. This self-inflicted problem could have been avoided if only she had control of her emotions.

➢ **Lesson**

1. Your look does not affect who you are.
2. Where you are at the moment is a result of your thought process,

➢ **Possible reasons why we magnify this lie**

1. Do you believe that we are defined by our weight and why?

➢ **Goal**

1. What action do you need to adopt today to help you live healthy and purposefully.

2. Create a mantra filled with positive words about your life.

3. How do you intend to sieve the media you are exposed to and get rid of the junk you listen, view, watch and read?

4. You want to achieve a healthier and fulfilling life; map out how you want to get there.

➤ Action steps to get you where you ought to be

1. Be intentional about taking good care of your health.
2. Surround yourself with positive models and not those that leave you even more depressed than you originally were.
3. Prepare in advance to win.

➤ Check list to note as you embark on this journey

1. Take hold of your emotions.
2. Erase negative talks from your mind and replace them with positive ones.

Chapter Eighteen: The lie: I need a drink

Drinking problem has become one of the predominant issues in our world today. Knowing your alcohol tolerance level is very paramount. But we all know that this doesn't only apply to alcohol. For everything about life, moderation is vital.

Rachel's ordeal, shows expressively how she didn't go a day without drinking but when she decided to quit, which wasn't easy, made her a better person and surprisingly, she didn't feel the desire to drink anymore. We can conclude here that at a point she was addicted to drinking. Strong will and resolve made her stand her ground and defeated her drinking problem. If Rachel can do it, so can you.

➢ **Lesson**

1. Only a brave person that will admit to their drinking, smoking and other addiction issues
2. It's okay to seek professional help.
3. You can't move past a problem without admitting it.

> ## Possible reasons why you are still holding on to that drink

1. What satisfaction do you derive when you ingest or exercise your addiction; be it alcohol, pills, habit etc.?

2. Overtime, has drinking helped your depression or frustration and how?

3. Does a little bit of alcohol really takes away the anxiety and bring contentment?

➤ **Goals**

1. Draft out a working plan to gradually stop drinking, cold turkey does not work for everybody.

2. Write out those factors that cause you to return to that addiction? After identifying them, cut them off your life.

3. What other ways do you deal with stress asides alcohol intake?

➢ **Action steps to get you where you ought to be**

1. Instead of finding solace in your addiction, hang out with friends or take a long walk to cool off.
2. Acknowledge that the habit is detrimental to your entire wellbeing; only then can you really get to work on it.
3. Stay far away from the temptation, in fact, don't mistakenly bring it in into your home.

➢ **Checklist to note as you embark on this journey**

1. Watch those habits that bring out the worst in you and cut down on them.

Chapter Nineteen: The lie: there's only one right way to be

Here is another common lie we often tell ourselves. There is never only one right way to be. It's in diversity that we thrive and be better. Leave your comfort zone to explore the world; don't be comfortable in that space you occupy now because there is always more to give and more to gain.

Staying confined to one place limits your scope and you discover that when you finally decide to know more there is a lot you have to learn and will not blend in properly with the rest of ther people.

Adjust your posture a little bit and it will change the way you view life, the way you speak, the way you listen and only then will you begin to see people for who they are and not the social strata they belong to.

> **Lesson**

1. There is no laid down rules on how life should be

➤ **Possible reasons why you feel that there is only one right way to be**

1. What is your view of life?

2. Did your upbringing encourage diversity or otherwise?

➤ **Goals**

1. What will you do today to push you off that comfy corner of yours and see that there is not only one way to be?

2. What personal measure will you adopt to be the best you can be?

> **Action steps to get you where you ought to be**

1. Change location, church, school, mosque, clubs... make sure you are not interacting with the same people you are used to.
2. Since you are new to the terrain, feel free to ask questions.

> **Checklist to note as you embark on this journey**

1. Approach the change with an open mind.
2. Get ready to learn to adapt to the change.

Chapter Twenty: The lie: I need a hero

Realizing that being your own hero is all you need to succeed in any endeavor you aim to achieve, as long as you are eager to work the work.

➢ **Lesson**

1. No one can be your own best hero, only you can.
2. You are your own inspiration; no one can inspire you as good as you would to yourself.
3. You have the sole ability to change your life. Don't waste your time waiting up on someone to help you or make it easy for you as there is no easy way out; you need to work hard to get all you desire out of life.

➢ **Possible reasons why you feel you need a hero**

1. Why do you feel the void of a hero?

2. All your life, have you depended on others to show you the part to success and why?

> **Goals**

1. How do you intend to be your own hero?

> **Action steps to get you where you ought to be**

1. Quit the tears, wipe them off and get to work. How long do you want to dwell there?
2. Discard those lies you have been telling yourself and launch into your goals like no one else matters and get what you deserve.